ART DECO
ANDREW CASEY

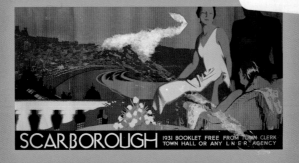

SCARBOROUGH 1931 BOOKLET FREE FROM TOWN CLERK TOWN HALL OR ANY L·N·E·R· AGENCY

AN LNER
POSTER FOR
SCARBOROUGH,
1931.

The world of Art Deco was sumptuous, decorative and opulent and it exploded onto an unsuspecting world during the 1920s. Starting in France, it soon spread across the western world, influencing a population ravaged by war and desperate for colour and extravagance. This unique style – rather than a movement – had no leader or manifesto but it made an enormous impact and left a legacy of good modern design across Europe and into North America.

The Art Deco period also ran parallel with immense social, cultural and economic changes. Women enjoyed more freedom and increased employment opportunities. Better communications, air travel and more leisure activities did much to improve the standard of living for thousands of families. Many people were now able to buy their own homes; they needed functional household objects and desired stylish new furnishings.

In retrospect, Art Deco was not only an influential period in the history of 20th-century style but also one of the most innovative and eclectic periods in the decorative and applied arts. Interestingly, the term 'Art Deco' wasn't coined during the period but was first used following a retrospective exhibition in the USA during the late 1960s (see page 20). ○

The Art Deco style rose to prominence during the early 1920s and followed on from the Art Nouveau movement that had proved popular during the period 1890–1910.

Art Nouveau was characterized by organic and natural forms and was stylistically very different to Art Deco. Whilst the exact dates for Art Deco are unclear, it is certain that the style originated in France and crystallized at the *Exposition Internationale des Arts Décoratifs et Industriels Modernes* held in Paris in 1925. This seminal exhibition, which was intended as a showcase for modern and avant-garde design, had been planned for some years earlier but was postponed because of the First World War. The works of major manufacturers and individual designers in the fields of glassware, silverware, textiles, furniture and interior design, were brought together in specially built pavilions. The stipulation was that designers had to create entirely original new objects excluding imitation of and inspiration from traditional styles. To create new ideas designers looked at a wide range of sources, including fashion, the arts and the ancient world. For many years Paris had led the world of fashion and when the famous Ballets Russes of Sergei Diaghilev came to Paris in 1909 it caused a sensation. The exotic and colourful costumes and stage designs promoted a fascination with vibrant colour and abstract forms. Many artists and designers were influenced by the vivid spectacle. Sonia Delaunay and Raoul Dufy exploited the use of bold colours whilst Pablo Picasso and Georges Braque, who were working in Paris at the same time, explored their interests in the African arts, which in turn directly influenced the Cubist Movement.

A RENÉ LALIQUE
VASE, ABOUT
1932.

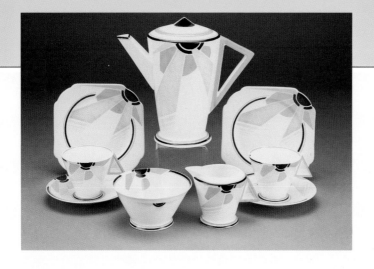

Art Deco encompassed many styles and influences. Designers looked for inspiration from ancient cultures such as the Aztec and Egyptian. In particular, the discovery of the tomb of Tutankhamun in Egypt in 1922 had a powerful impact on designers and strongly influenced their work. For instance, the stepped pyramid shapes were used in buildings and in furniture. Other popular decorative motifs included tigers, birds, leaping deer and fountains. A prominent motif, especially favoured in Britain, was the sunburst.

In general, Art Deco had a less significant impact in Britain, as public taste was less adventurous and many sectors of society continued to buy long-established designs rather than choosing to embrace the new style. The best examples of British Art Deco can be seen in the new buildings and on hand-painted ceramics.

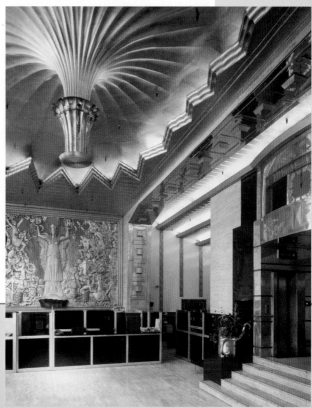

THE CHRYSLER BUILDING, BUILT TO CELEBRATE THE SUCCESS OF THE FAMOUS CAR COMPANY, WAS DESIGNED BY WILLIAM VAN ALEN AND COMPLETED IN 1930.

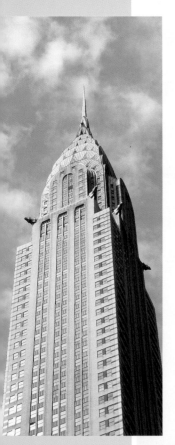

Art Deco architecture, unlike most disciplines in the period, originated in North America. Art Deco architects and interior designers worked closely together to create renowned skyscrapers, such as New York's Empire State Building, Rockefeller Centre and Chrysler Building. The distinctive stepped shape developed following the New York authorities' ruling, in 1916, that all new buildings had to be set back in stages to allow light into the street. Each featured exterior surface ornamentation, decorative ironwork and exuberant murals in the foyers. Colour found a place on the exterior of new Art Deco buildings in Miami, which were painted in bright pinks and blues to reflect the warm climate.

Whilst the monumental aspects of Art Deco architecture did not cross over to Europe, some elements can be found across the world. Those new buildings without any tradition behind them, such as airport buildings and cinemas, often bore Art Deco styling. In the UK, outstanding examples of exteriors include London's Hoover Building and British Broadcasting House (BBC), the latter of which was deemed rather too modern by many British people. Relevant interiors include the foyer of the Daily Express Building, the elegant Park Lane Hotel and the exquisite Art Deco room at Eltham Palace. One example further afield is the Midland Hotel in Morecambe, which was designed by Oliver Hill.

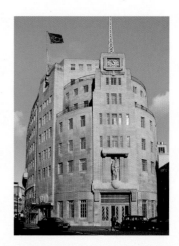

BRITISH BROADCASTING HOUSE, LONDON, DESIGNED BY G. VAL MEYER AND F. J. WATSON-HART, 1931–2.

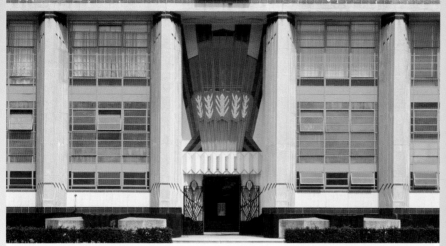

HOOVER LIMITED

The 1930s was the decade of the cinema. Sound had been introduced in the late 1920s and the British public went en masse to these 'palaces of entertainment' to be sold the glamorous dream of Hollywood. The Odeon cinema chain was responsible for some of the finest Art Deco cinemas across the country; two examples are the Odeon in Sutton Coldfield and that in Woolwich. In the Netherlands, the Tuschinski Theater in Amsterdam was a particularly striking example, with stylized ironwork, painted murals and a bold façade.

All these architectural delights have come to epitomize Art Deco and at the same time have left us with a permanent reminder of the achievements made by architects, artists and designers of the period. ●

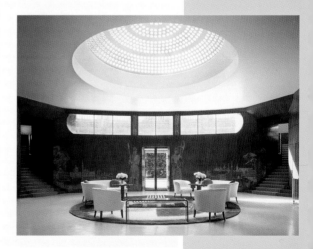

THE ENTRANCE HALL,
ELTHAM PALACE,
DESIGNED BY
ROLF ENGSTROMER,
1933–4.

The development of Art Deco furniture started before the First World War in some of the many Paris studios, based on cabinet making from the previous century. The move away from Art Nouveau resulted in designers progressing towards a streamlined style coupled with the use of expensive and exotic veneers that created a rich, opulent effect. The designer Emile-Jacques Ruhlmann, who had his own pavilion at the 1925 Paris exhibition, was the master of Art Deco furniture during the 1920s. Alongside Ruhlmann other designers such as Robert Mallet-Stevens and Paul Follot also shared the same interest in creating the whole interior. Initially French Art Deco furniture was expensive and often specially commissioned by rich clients. However, as changes took place in both the needs of the market and technological advances, more affordable furniture began to be manufactured. This was facilitated as new materials – such as chrome and plywood – were used for reproduction for the mass market. Changes in lifestyles also prompted designers to introduce special items such as cocktail cabinets.

Although it is acknowledged that the best examples of Art Deco furniture originated in France,

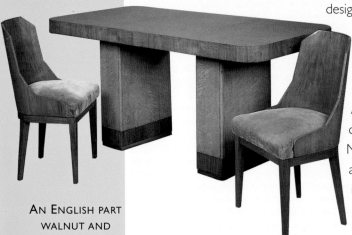

AN ENGLISH PART WALNUT AND BIRD'S EYE MAPLE DINING SUITE, ABOUT 1935.

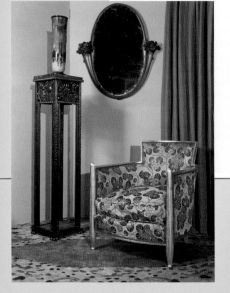

A COLLECTION OF FRENCH FURNITURE INCLUDING A STAND BY NICS FRERES AND CHAIR BY MERCIER FRERES, ABOUT 1925.

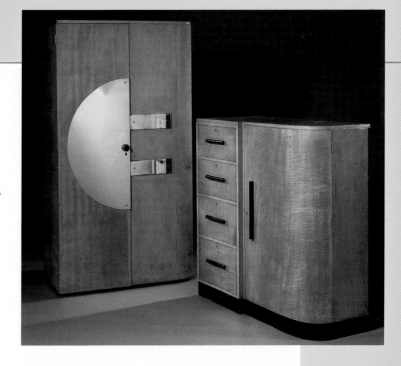

A SATINBIRCH AND EBONIZED CABINET AND A BIRCH TWO-DOOR WARDROBE.

Britain also produced several important pieces. British designer Betty Joel focused on furniture and the modern interior. Together with her husband, she set up Betty Joel Ltd shortly after the First World War. Her London showroom presented her French-style Art Deco furniture, rugs and textiles, and her distinctive style proved very popular. Eileen Gray, a contemporary of Joel's, was born in Ireland and studied at the Slade School in London but settled in Paris in 1907. She set up a workshop selling furniture and rugs that she had designed, later developing dramatic modern tubular furniture and lacquered screens. Both Joel and Gray moved away from over-ornate furniture to a simpler style, anticipating the move towards Modernism.

In the USA several designers created outstanding examples of Art Deco furniture, the most important being Desmond Deskey. Deskey was also responsible for the interior decoration of Radio City Musical Hall in New York. Paul T. Frankl designed furniture inspired by skyscrapers. ●

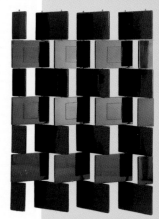

A BLACK LACQUERED SCREEN DESIGNED BY EILEEN GRAY, ABOUT 1925.

Posters and other publicity materials have always proved to be one of the most influential ways of selling a product, but at the same time they reflect an image of society at a particular point in time. The high quality and originality of Art Deco posters were due in part to two developments.

Firstly, during the 1920s, commercial design had begun to be taken more seriously as a profession and, secondly, the strong influence of contemporary arts resulted in an innovative and appealing product. Above all, poster designs reflected changes in lifestyle, with many examples selling the possibilities of new forms of travel, communications, modern domestic power and entertainment. In addition to this, the graphic arts became more dramatic as advances in production methods allowed for more adventurous use of colour. In time this attracted established artists and designers to the discipline.

The two leading exponents of Art Deco poster design were Edward McKnight Kauffer and A.M. Cassandre. Whilst they embraced similar artistic influences, their work was quite different in style. This is evident in the Frenchman Cassandre's posters for the *Nord Express* from 1929, using striking

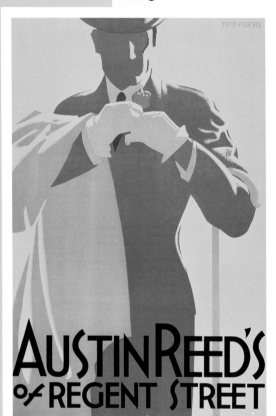

AN AUSTIN REED POSTER DESIGNED BY TOM PURVIS, ABOUT 1935.

typography, and the cruise liner *Normandie* from 1935. Edward McKnight Kauffer was born in the USA and worked in Britain during the 1920s for several companies, including the London Transport Board and the Empire Marketing Board. His work recognized and utilized the ideas of contemporary art, especially its more abstract qualities. The designer Paul Colin was another of the most celebrated French poster designers of this period.

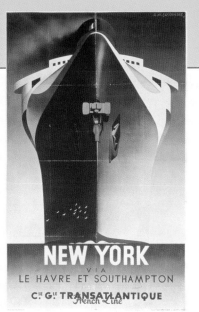

A POSTER FOR
THE FRENCH
LINE BY
A.M. CASSANDRE,
ABOUT 1935.

The graphic designs and illustrations by Erté and Georges Lepape were more decorative and were often used for advertising in the retail trade. In Britain, stores such as Heal's and Austin Reed used publicity to both advertise their products and promote a modern and exclusive brand image. Graphics were also used on packaging for perfumes and cosmetics and for book and magazine covers. In particular, fashion magazines such as *Vogue* and *Harpers and Queen* used a wide range of artists to create attractive and modern covers to promote sales. ●

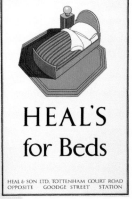

A HEAL'S POSTER
DATING FROM THE
1920s.

'NUNNEY'
HOLIDAYS,
LMS POSTER,
1930.

'EAST COAST
FROLICS', A
LNER POSTER,
1933.

During the Art Deco period ceramics continued to be made for a variety of markets, from special one-off exhibition pieces to mass-produced tableware. French ceramists led the way with a vast array of subject matter, from the stylized nudes typified by the work of René Buthaud to grazing deer by Primavera. Jean Luce and Charles Catteau also produced sumptuous vases.

The Paris exhibition of 1925 had a tremendous effect on many British designers, as the vogue for hand-painted decoration provided them with creative opportunities that traditional printing methods could not. However, it was the bigger manufacturers – who could afford to invest in new design – that made a significant contribution. A notable example was Wedgwood who revived a number of hand-painted patterns. In Britain the majority of the industry continued to produce past designs and the middle-class market was still very conservative. Whilst some of the smaller manufacturers could not afford to invest in new shapes, others believed that there was not a big market for Art Deco pottery. However, a number of companies produced more populist ceramics following the flood of brightly painted Czechoslovakian pottery onto the British market. This style was typified by the work of Clarice Cliff. Her pottery was inspired by the contemporary arts and caused a sensation within the conservative pottery industry but proved to be commercially successful on the international market. Cliff has come to epitomize British Art Deco ceramics.

A VASE BY TRUDA CARTER DECORATED WITH A FRENCH-INSPIRED PATTERN, ABOUT 1928.

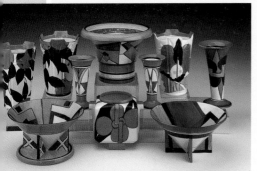

A SELECTION OF CLARICE CLIFF POTTERY. SOME OF HER PATTERNS TOOK THEIR INSPIRATION FROM THE *POCHOIR* PRINT BOOKS THAT WERE PRODUCED IN FRANCE BY DESIGNERS SUCH AS EDOUARD BENEDICTUS.

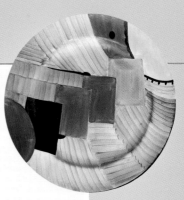

A SUSIE COOPER CHARGER DECORATED WITH THE CUBIST PATTERN, ABOUT 1925.

Amongst the several other important designers was Truda Carter. During the 1920s and early 1930s she introduced a dramatic range of bold geometric patterns for Carter, Stabler and Adams Ltd based in Poole, Dorset. The Shelley Potteries, better known for their classically-styled bone china coffee sets, produced a number of wares inspired by the style, under the direction of Eric Slater. His new modern shapes, including 'Mode' and 'Vogue', were decorated with stylish but restrained patterns, such as 'Blocks' and 'Sunray', that proved popular with the market.

For a short period Susie Cooper produced a range of Art Deco-inspired lustre wares and hand-painted geometric patterns as chief designer at A.E. Gray and Co. Ltd. These were short-lived as Cooper later moved on to restrained patterning using simple bands, spots and dashes decorated on streamlined shapes that appealed to the market. In Sweden, Wilhelm Kage produced decorative items, including the 'Argenta' range for Gustavberg Porcelain Works and in Austria Goldscheider introduced a series of stylized figures.

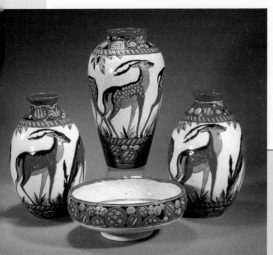

EXAMPLES OF POTTERY DESIGNED BY CHARLES CATTEAU FOR KERAMIS, ABOUT 1925.

lass inspired the Art Deco designers to conjure up dazzling patterns and bold new shapes during this highly decorative period. Across Europe, many themes based on ancient cultures and stylized and geometric motifs were exploited to great dramatic effect. The most important name in Art Deco glass was René Lalique. Having successfully made the transition from Art Nouveau to Art Deco, Lalique created a stunning range of glass products that were full of flowing movement and iridescence, unmatched by any other manufacturer. His well-known creations ranged from the statuette 'Suzanne' to more functional glass that still retained a feeling of opulence. Despite the stylish productions of Lalique, the major contribution to Art Deco glass came from Scandinavia rather than France, in particular the innovative approach to design by the Orrefors Glass Works, based in Sweden. They set new standards by employing a number of artists and designers – such as Simon Gate and Edward Hald – who not only improved current glass-making techniques, but also developed new decorative treatments. Vases depicted stylized dancers or sporting themes, finely engraved on the panelled glassware. However, most examples were out of reach for the ordinary customer.

The Art Deco style lent itself to the pressed glass method of production that allowed British manufacturers to produce large quantities of stylish glassware at a fraction of the cost of the best French examples. The Jobling company issued pressed opalescent glass that was created from specially commissioned moulds from France. At first the British glass industry was slow to develop new contemporary patterns, preferring to produce period styles. However, some manufacturers

AN ORREFORS VASE, ABOUT 1930.

A MONART GLASS VASE
DECORATED INTERNALLY
IN PURPLE AND BLUE
WITH AIR BUBBLES,
1925.

realized that to reach new markets the quality of design had to be improved. Stevens and Williams Ltd contracted the designer Keith Murray, whilst the Moncrieff Glassworks in Scotland employed the Spanish glassmaker Salvador Ysart to create new lines for them (under the Monart name) to much financial success. Other glass companies of this period included White-friars, James Powell and Sons Ltd and T. Webb and Corbett Ltd. ●

A KEITH MURRAY VASE EXHIBITED IN THE PARIS EXPOSITION IN 1937.

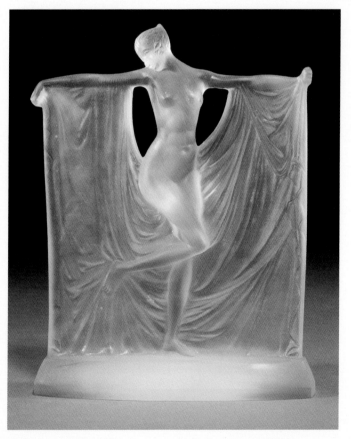

THE 'SUZANNE' FIGURE BY RENÉ LALIQUE, 1920S.

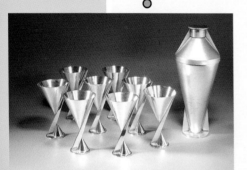

hroughout the period designers used a wide range of metals including silver, bronze, iron and later aluminium to create outstanding examples of Art Deco. The advances in production and manufacture made it possible for designers to create more intricate and ornamental ironworks, for example decorative panels for public buildings (such as those in New York) as well as simple geometric forms for tea services and cigarette lighters.

With the construction of new skyscrapers and public buildings, architectural metalwork came to the forefront. In France the most prominent designer, Edgar Brandt, pioneered the use of wrought iron for decorative gates, light fittings and lamps that featured floral motifs, animals and stylized figures. Brandt, who demonstrated the notion of complete design, undertook several major commissions in North America. Other European designers, such as Peter Müller-Munk and John P. Petterson, soon followed.

The impact of the modern 'Danish style' silver across Europe and North America brought a number of Danish designers to the forefront of the industry. This was due in part to the innovative work of Georg Jensen and Harald Nielsen. The North American company Gorham Manufacturing Co. employed Eric Magnusson. His coffee set 'The Lights and Shadows of Manhattan', dating from 1927, featured triangular facets and reflected the impact New York must have made on him.

A COCKTAIL SET DESIGNED BY MAISON DESNY, ABOUT 1930.

A CHROME-PLATED NOVELTY LIGHTER MODELLED AS A MG MAGIC MIDGET MADE BY THE BRITISH COMPANY ASPREY, ABOUT 1933.

A 'BALLERINA' POWDER
COMPACT, MADE BY
DUBARRY, 1920–30.

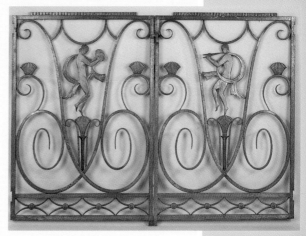

In Germany M.H. Wilkens and Söhne produced a number of Art Deco wares (such as a decorative candelabrum in Germany, 1925) alongside Bernhard Hotger, who produced a striking mocha set by 1927.

Silversmiths responded to the prevailing fashion for drinking and smoking by producing new items such as cocktail sets.

Jean Emile Puiforçat was the exponent of Art Deco silver. His handmade work was very expensive. Apart from Puiforçat, the French did not achieve the same distinction in Art Deco silverware, although some designers from outside the industry, such as Emile-Jacques Ruhlmann, produced more adventurous designs. By the late 1920s the strong geometric styles were influenced by modernists. A notable example is a striking conical-shaped cocktail set designed by Maison Desny that contrasted greatly to a set by Keith Murray. Henry George Murphy created a dynamic Art Deco silver tea set alongside a more modern design by Harold Stabler for Adie Brothers Ltd.

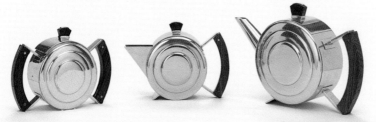

TWO SILVER TEAPOTS AND SUGAR BOWL DESIGNED BY
HENRY GEORGE MURPHY, ABOUT 1931–2.

A rt Deco jewellery was created against a backdrop of immense change in both the world of fashion and the decorative and visuals arts. The outstanding and distinctive range of Art Deco jewellery and associated accessories, such as cosmetic cases and cigarette holders, represented a strong sense of style and fashion. Costume jewellery was also very popular. Women

A GOLD AND SILVER BROOCH WITH LAPIS LAZULI AND BLUE GLASS, DESIGNED BY RAYMOND TEMPLIER, ABOUT 1934.

A RUBY AND DIAMOND NECKLACE BY MAUBOUSSIN, ABOUT 1925.

had more freedom and independence than previously; they were experimenting with new styles such as cloche hats and short hair and their jewellery had to complement this. The names at the cutting edge of design in France were Jean Fouquet, Gérard Sandoz and Raymond Templier. Jean Dunand, who worked in many forms of the applied arts, also produced a stunning selection of Art Deco jewellery, shoe buckles, match cases and bracelets.

The requirement that all the exhibits at the 1925 Paris exhibition should not be derived from traditional styles, and that imitation would not be allowed, prompted these young French designers to create an original look by using a combination of new shapes and

different cut of stones and materials, mixing them together for the greatest visual impact. They rejected representational motifs such as flowers and animals, favouring sharp edges, geometric forms and abstract patterns with an emphasis on broad plane surfaces. This choice reflected the growing influence of contemporary art – especially Cubism – promoted by artists such as Pablo Picasso and Georges Braque. One jeweller, Jean Desprès, was a personal friend of these two artists. Shapes such as squares, circles and triangles were preferred. Furthermore, materials were chosen for their decorative quality rather than for their intrinsic value and they were mixed together – often unconventionally – for the maximum visual appeal.

The leading jewellery firms of Paris, such as Cartier and Van Cleef and Arpels, responded to the popularity of the style by producing luxury ranges for the very wealthy using expensive stones. In particular Cartier, founded in 1847 by Louis-Francois Cartier, was inspired by the vogue for Orientalism alongside other influences. Despite a number of British jewellers exhibiting at the Paris exhibition of 1925, including Wright and Hadgkiss Ltd, Britain's response to the new style was rather limited. Contemporary jewellery tended to hark back to the Art Nouveau period rather than embrace the strident shapes and colours of Art Deco. ●

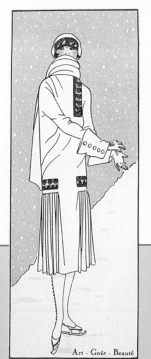

'SKATING ELEGANCE',
A FASHION PLATE FROM
ART, GOUT, BEATE,
PUBLISHED IN PARIS IN
THE 1920S.

AN IVORY, ONYX AND CORAL
INSET WITH DIAMONDS ART
DECO PENDANT,
ABOUT 1925.

The 'Snake Charmer' by Otto Poertzel. Cast from a model on striated marble base, 1920s.

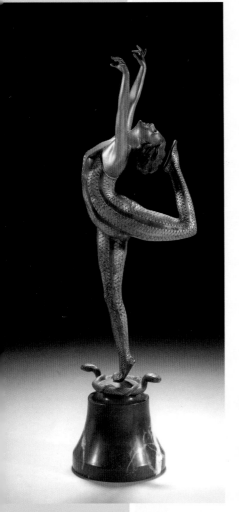

During the inter-war period, art and sculpture flourished. Whilst contemporary painting cannot really be defined as Art Deco, the work of several artists was clearly influenced by the style.

Many artists worked closely with architects and designers towards creating the interiors for public and residential buildings. A number of artists were commissioned to produce murals, decorative scenes or paintings to adorn spaces such as the interiors of luxury cruise liners or skyscraper entrance lobbies.

One of the most important painters in Paris was Jean Dupas. He worked across the disciplines of the applied arts both as a designer and artist. His work was displayed in one of the pavilions at the Paris exhibition in 1925. One of his spectacular commissions was the glittering gold panel depicting galleons for the *Normandie* cruise liner. Dupas often chose to use neoclassical imagery that easily transferred to posters and illustration work.

One painter who has come to epitomize the Art Deco period was Tamara de Lempicka. Born in Warsaw, she moved to Paris during the 1920s and painted pictures of Parisians including socialites, actors and fellow artists. Her work showed the influence of Cubism and reflected the fascination with the machine age. In Britain, some of the most notable painters included Glyn Philpott and Dod Procter. The artist and illustrator Eric Ravilious produced a mural for the new Art Deco Midland Hotel in Morecambe.

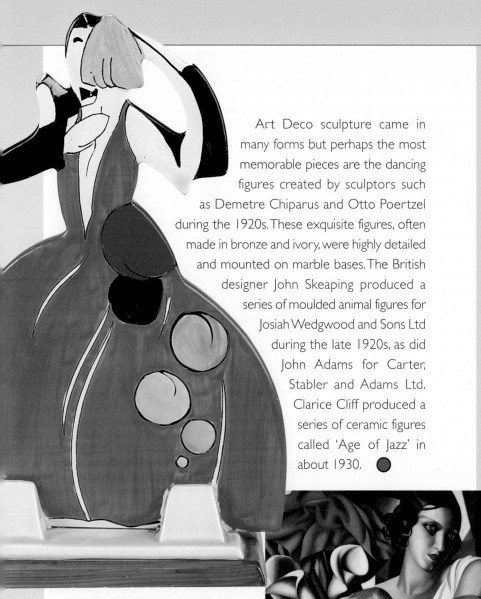

Art Deco sculpture came in many forms but perhaps the most memorable pieces are the dancing figures created by sculptors such as Demetre Chiparus and Otto Poertzel during the 1920s. These exquisite figures, often made in bronze and ivory, were highly detailed and mounted on marble bases. The British designer John Skeaping produced a series of moulded animal figures for Josiah Wedgwood and Sons Ltd during the late 1920s, as did John Adams for Carter, Stabler and Adams Ltd. Clarice Cliff produced a series of ceramic figures called 'Age of Jazz' in about 1930.

AN 'AGE OF JAZZ' FIGURE BY CLARICE CLIFF, ABOUT 1930.

PORTRAIT D'IRA P. BY TAMARA DE LEMPICKA, 1926.

The Art Deco style ended when the Second World War started in 1939. By the late 1960s, some 30 years later, a renewed interest in this important period in the decorative arts began. As had happened with other trends, a new exhibition and book helped promote the style to a much wider audience.

The exhibition was entitled *Les Années 25 – Art Deco, Bauhaus, Stijl, Esprit Nouveau* and was staged in Paris in 1966. The book, *Art Deco of the Twenties and Thirties* by Bevis Hillier, published two years later, also did much to advance interest. The influential London store Biba opened during the late 1960s and created an Art Deco 'experience', selling clothes and other fashion products. Moreover, examples of Art Deco, such as ceramics and furniture, could be purchased from fleamarkets for a low price. In 1972 Brighton Museum held a groundbreaking exhibition of Clarice Cliff pottery and at the same time the interest in all things Art Deco was reflected in films such as *The Great Gatsby* and *The Boyfriend*.

During the late 1970s and early 1980s the Italian Memphis design group, based in Milan, made a significant impact on contemporary design with an extensive range of furniture and ceramic pieces that displayed not only an Art Deco influence but echoed the Art Deco notion of designing the whole interior. Memphis went on to influence young designers internationally. ●

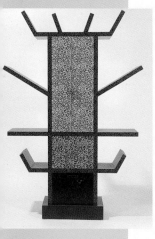

THE CASABLANCA
SIDEBOARD
DESIGNED BY
ETTORE SOTTSASS,
1981.

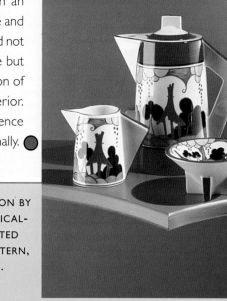

A CLARICE CLIFF REPRODUCTION BY
WEDGWOOD. PART OF A CONICAL-
SHAPED COFFEE SET DECORATED
WITH THE 'SUMMERHOUSE' PATTERN,
FIRST LAUNCHED IN 1931.